Sketch This!

300 Sketching Prompts

© 2016 Piccadilly (USA) Inc.

This edition published by Piccadilly (USA) Inc.

Piccadilly (USA) Inc.
12702 Via Cortina, Suite 203
Del Mar, CA 92014
USA

10 9 8 7 6 5 4 3 2 1

Printed in China

ISBN-13: 978-1-60863-930-4

hat you imagine your conscience would look like.

u're standing on the edge of a mountain. Sketch what you see.

Your imagination is taking you to a mysterious land. Sketch it.

ur evil twin.

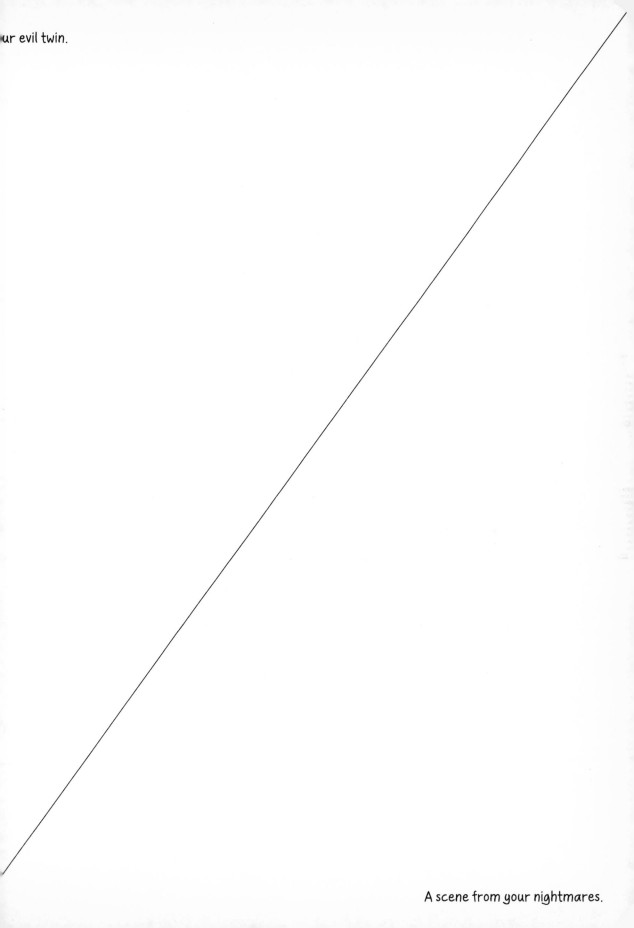

A scene from your nightmares.

What virtual reality would look like if you designed it.

side, outside or all sides—sketch a sports car you're in love with.

new dollar bill for your country with a denomination that doesn't exist.

What a magical forest looks like to you.

Your version of the sky falling.

A new mascot for a local football team.

ur interpretation of the "tree of life."

Leave your mark on Mt. Rushmore.

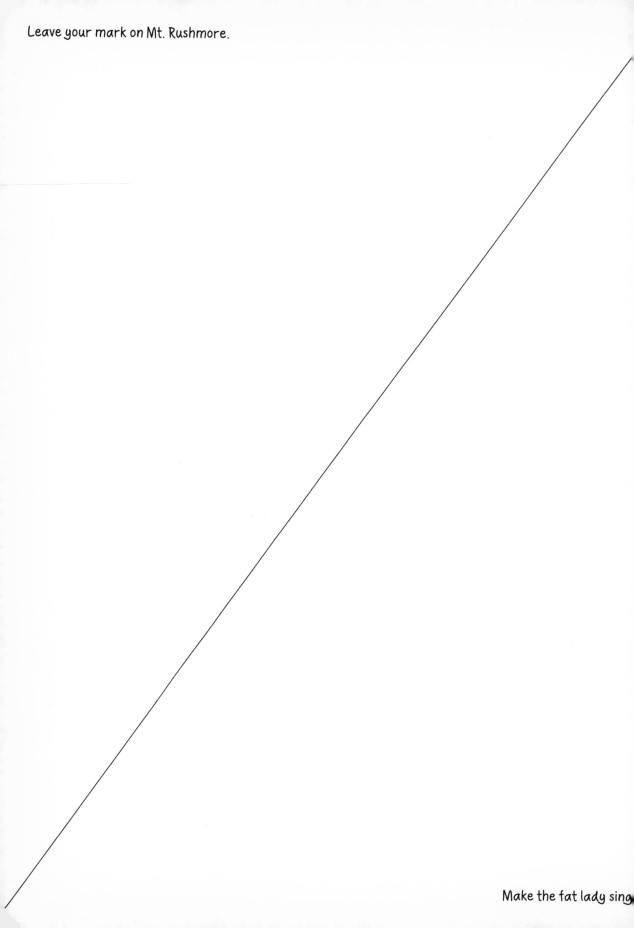

Make the fat lady sing.

u've just been reincarnated into something—sketch your new form.

What you think your spirit animal looks like.

ew species you found in the ocean.

Recreate the first step on the Moon.

An undiscovered solar system.

secret decoder ring.

esign and sketch your wedding cake or a friend's wedding cake.
apture every detail.

You're attending a lantern festival in Thailand called Loy Krathong. Sketch what you see from the riverbanks, to the sky and the wish lanterns (Khoom Fay) as they are released.

architectural plans for a new amusement park in your city.

A skeleton to be used in a science class.

A robot you're building.

farmer, his crops, barn and tractor. Give him character and a best friend.

A Hawaiian luau, complete with a pig roasting and hula dancers.

person or persons skydiving. Grab the emotion or excitement of the event.

he lifecycle or emerging of a butterfly.

Your neighborhood. Use bird's eye or street perspective capture the details.

A firefighter doing his job.

A monster you'd find hiding under your bed.

Your idea of what a superhero villain would look like.

ur version of Moby Dick vs. The Kraken.

A birthday party you're attending.

A scene from your favorite cartoon.

city skyline at sunset.

A Rastafarian playing the bongos.

The view out an airplane window as it's landin

e sun and its splendor. Give it a face like the Sun of May but your own interpretation.

parade that has never been seen before.

You're backpacking through a new place, what's your scenery?

new toy that has never been invented.

A sandcastle being attacked by crabs.

ake something that is fragile, yet indestructible.

discovery from deep space.

Something historic that is important to you.

3-dimensional maze with surprises.

Something you think will make people giggle, create a funny sketch.

What you think is inside a tornado's vortex during destruction.

A rare musical instrument.

A warrior with special powers.

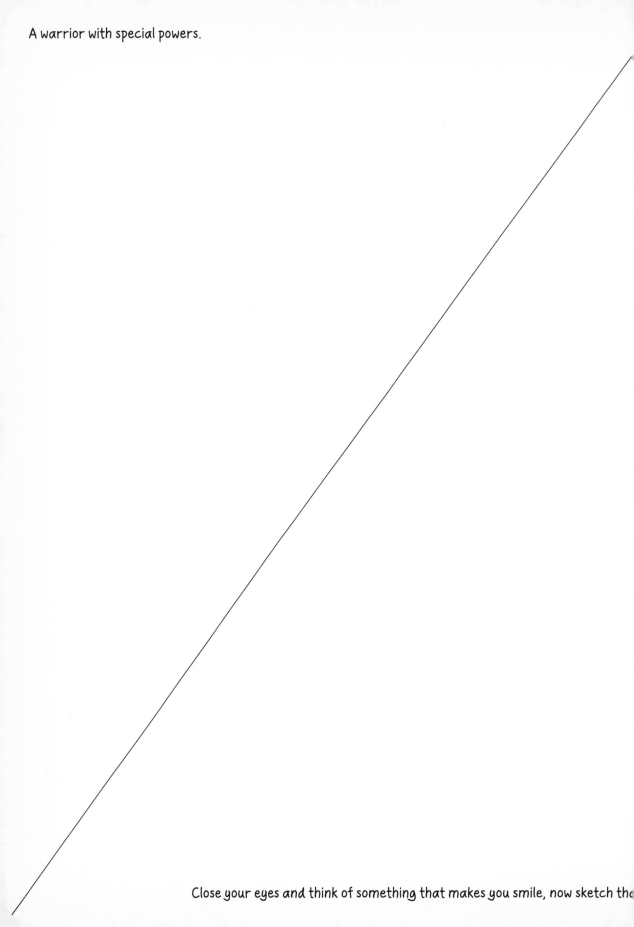

Close your eyes and think of something that makes you smile, now sketch tha

phabet soup but instead of using letters, use an object that begins with each letter and put it in the soup.

The face of your loved one.

The coolest slide in the world no one has ever built.

hat you think a zombie apocalypse would look like.

omething that would happen Halloween night.

Sketch a clip from your new comic book.

A wizard casting a spell.

scene from your African safari.

Take a trip back in time. If you invented the first telephone, what would it look like?

A scene you'd find on a postcard.

rzan's view as he swings through the jungle.

Bring something from the future to
the here and now.

Dracula's transformation with all the details

ur new design is replacing the Golden Gate Bridge—what does it look like?

Bring your morning breath to life via sketch.

Design a modern day Colosseum.

etch and design a new battleship for an army.

new motorcycle design for a big name manufacturer.

A game of pool you're playing—
looking down the eight ball.

A top floor view looking down a
complicated staircase.

carousel in motion, define each piece to be ridden.

ou're attending a protest you're passionate about. Sketch the emotion and don't forget the signs.

A castle with drawbridge.

Leap 100 years in the future, what do the freight trains look like now?

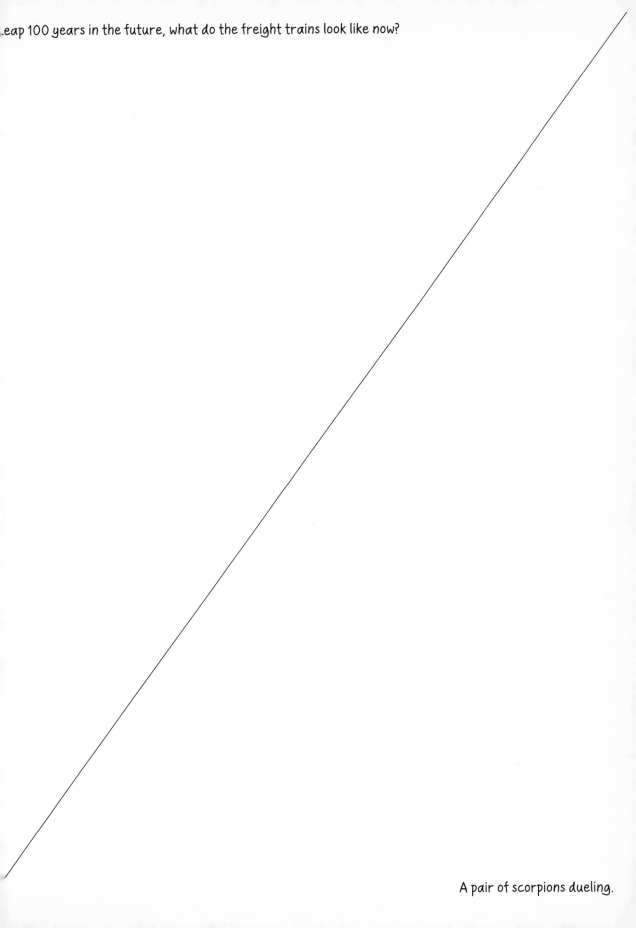

A pair of scorpions dueling.

A scene from the countryside.

e face of a sinister joker.

u've just made a birthday wish. Sketch what you've wished for.

Something haunted, bring the ghosts to life.

Your dream fish tank, complete with goldfish.

monkey deep in thought or learning.

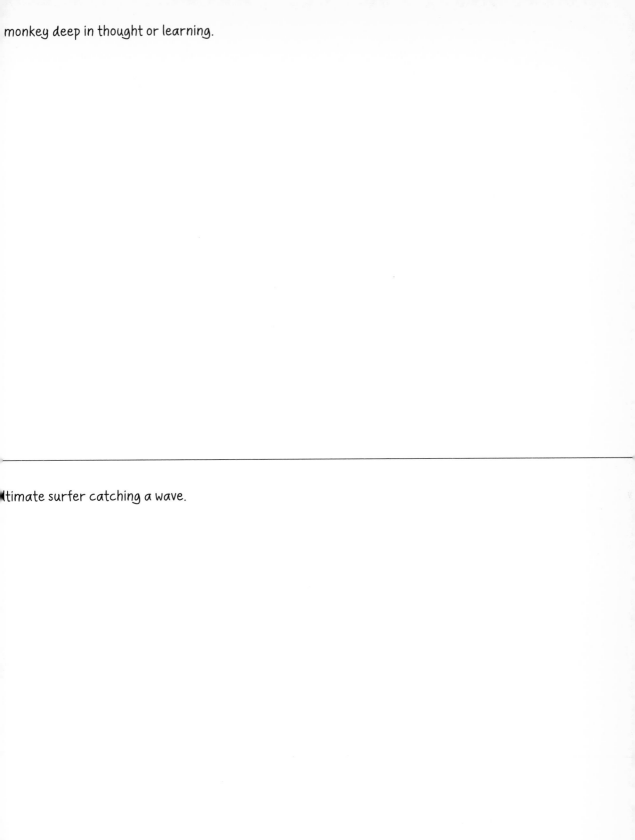

timate surfer catching a wave.

Inspire coulrophobia by sketching a scary clown.

winter wonderland.

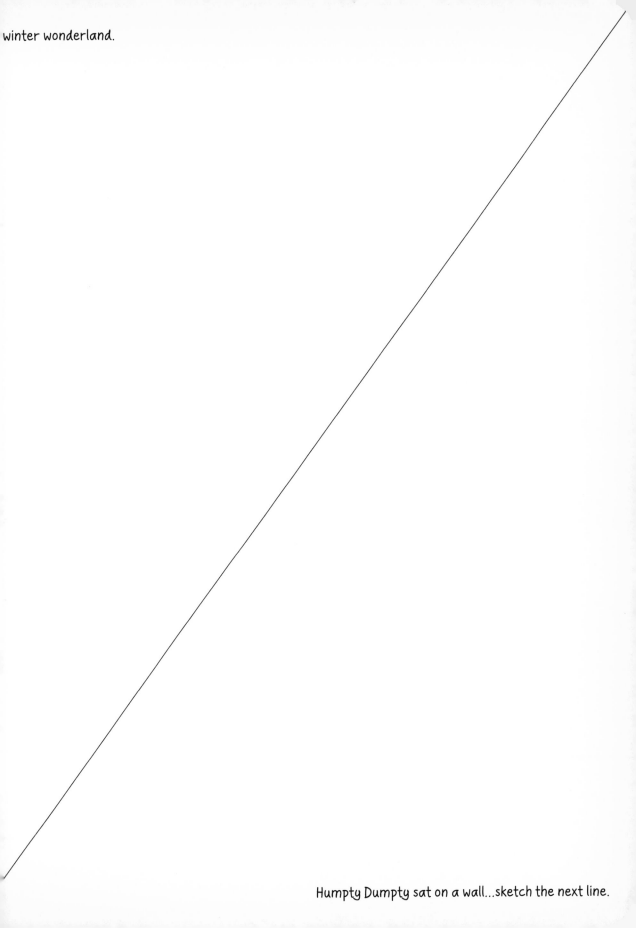

Humpty Dumpty sat on a wall...sketch the next line.

You're a movie star, what does your mansion look like?

An anaconda after prey.

You just bungee jumped, what's
your view on the way down?

Demolish a building using a wrecking ball.

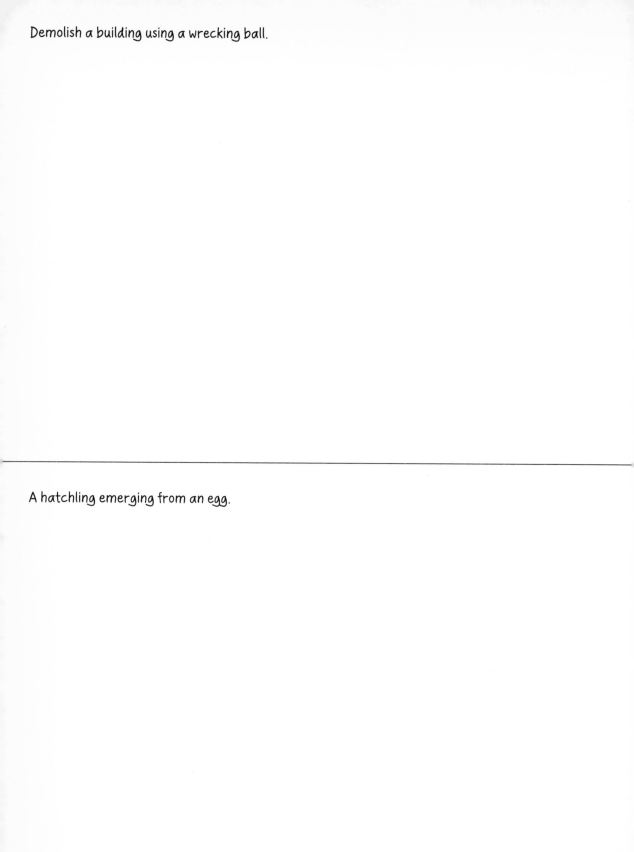

A hatchling emerging from an egg.

ketch a new family crest—showcase your lineage.

The Loch Ness Monster has just peeked out of the water in front of you.Sketch what it looks like.

The food in your refrigerator has come to life and is attacking you. Sketch the food fight.

ou've just finished a long, cross-country road trip. Sketch your favorite memory.

Design a freeway that prevents gridlock.

unicorn with wings.

You're on a trail ride. Sketch the adventure.

You have just discovered a new constellation. Sketch it across the sky.

A new high tech invention.

Sketch what your imagination at work looks like.

Sketch what you see in your rearview mirror.

The boogie man from your childhood.

A glorious fountain.

odzilla attacking Hollywood.

A phoenix emerging from a fire.

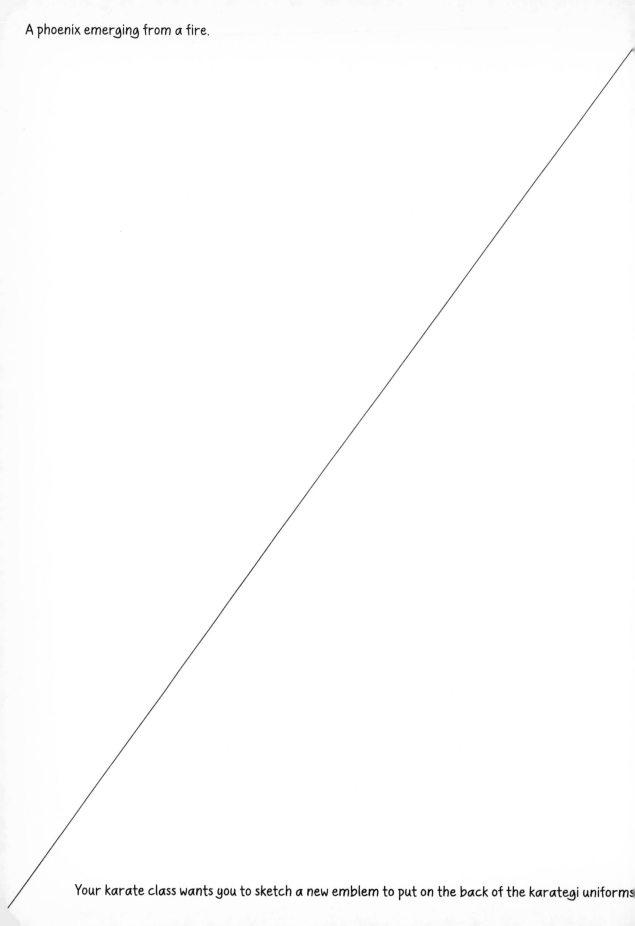

Your karate class wants you to sketch a new emblem to put on the back of the karategi uniforms

A raven sitting on a tombstone.

A rose as it wilts.

A skull with antlers.

A wagon wheel with a broken spoke.

view when hang gliding in the mountains.

u've accidentally been stranded on a remote island—sketch your surroundings.

Frankenstein coming to life.

You're on a reality TV game show and you're looking for an immunity idol, what do you think it looks like?

You're in charge of building a new restaurant in the sky. Sketch the design.

Sketch a modern day Zeus.

A close up of an orchid.

The aftermath of lightning hitting the ground.

You'll be competing in a chariot race but you have to design it first.

A light bulb shattering on the floor.

A dragon slayer and the dragon.

What you think two worlds colliding would look like.

When out rock climbing you came upon a cavern and descend below to find a mystical underground. Sketch all the wonders you see growing in the cavern.

Your guardian angel.

You've stumbled into a mad scientist's laboratory. Sketch what you see (don't forget the beakers).

The scales of justice.

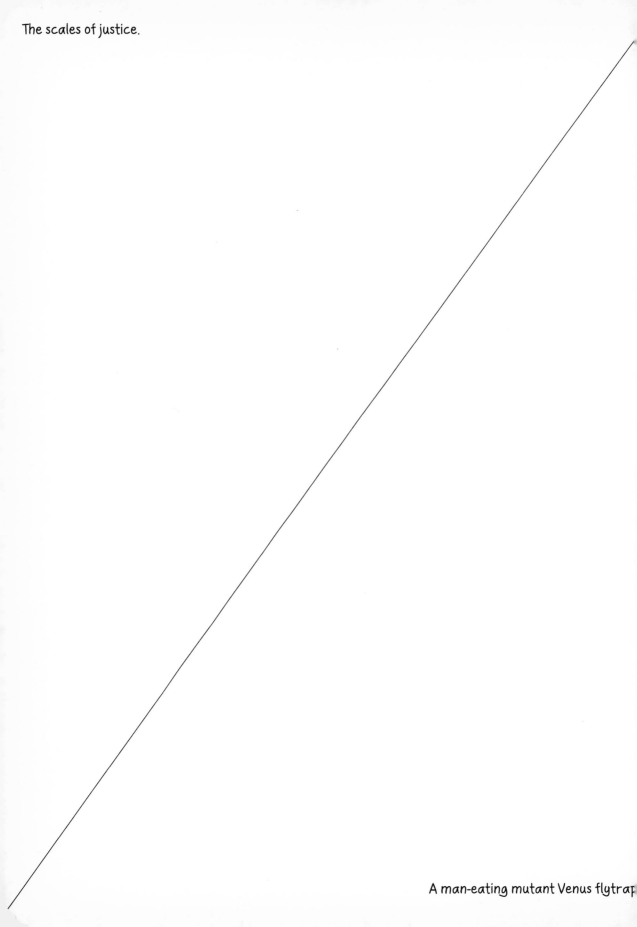

A man-eating mutant Venus flytrap

What you think the prehistoric landscape looked like—don't forget the dinosaurs.

Sketch what you think is happening metaphorically during your worst headache.

You're in charge of creating a lifelike billboard for Route 66 with a positive PSA to make people smile. Sketch your new creation.

A leprechaun got arrested—sketch his mug shot.

Your favorite poem interpreted into a sketch.

Sketch a new uniform for a soldier.

ombine man with an animal and create a new mythical creature.

You've discovered a new ancient ruins site. Sketch it.

Make the invisible man...visible. Sketch his transformation.

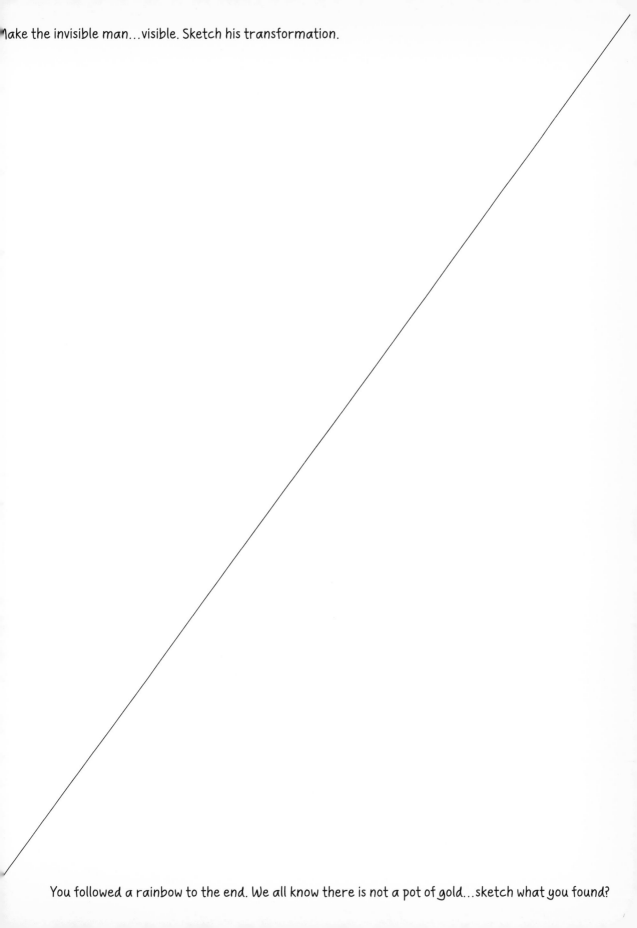

You followed a rainbow to the end. We all know there is not a pot of gold...sketch what you found?

A playground you wish you had as a kid.

You've been transported to London in the 1800s. Sketch your vision with cobblestone streets and lampposts.

Bring an extinct species back to life and make it able to adapt
to its new environment.

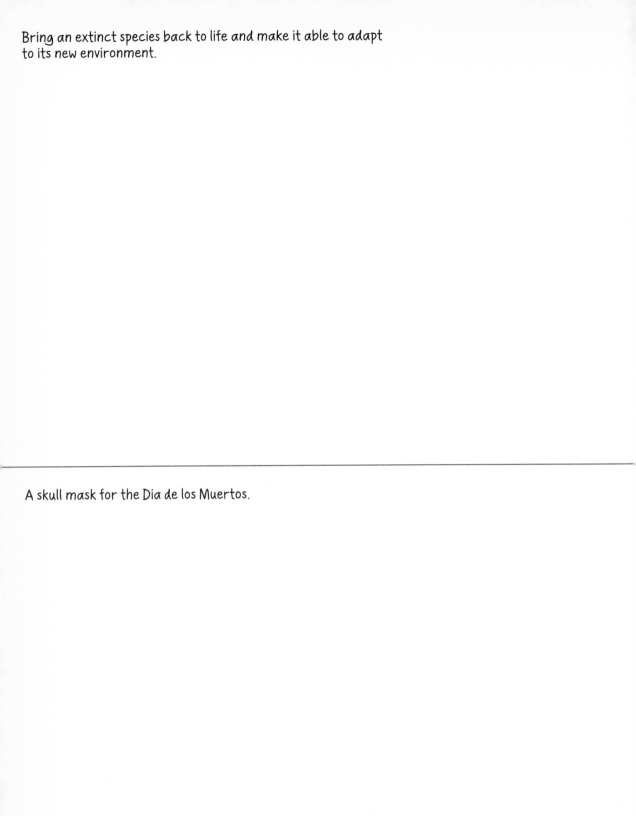

A skull mask for the Dia de los Muertos.

A fairytale jumping out of a storybook.

The Grim Reaper walking through a cemetery.

Life on another planet.

A majestic whale breaching from the ocean.

A village of gnomes.

You're exploring the Bermuda Triangle. Sketch something you found there.

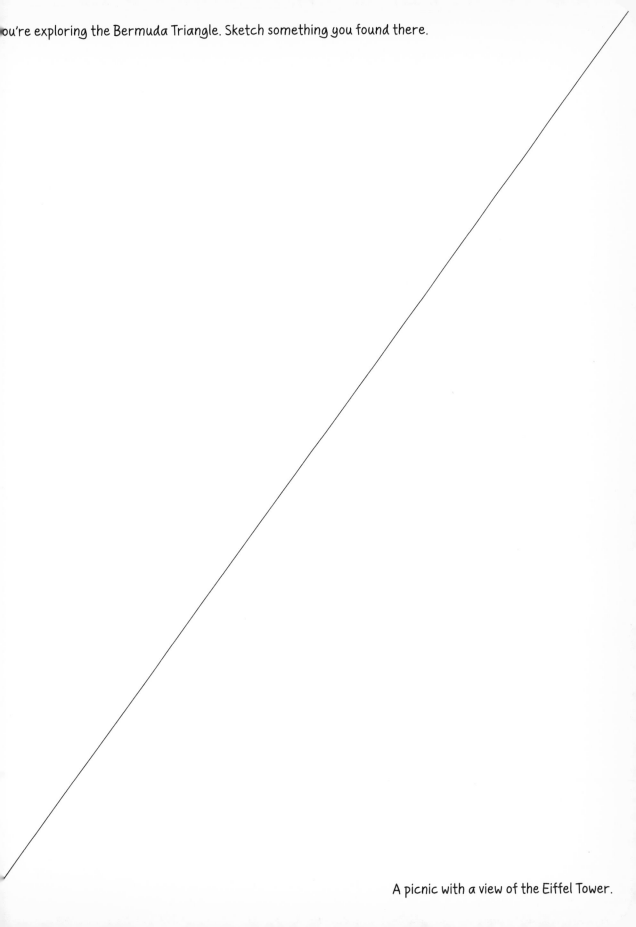

A picnic with a view of the Eiffel Tower.

What do you think the Lost City of Atlantis looks like?

You're in charge of designing a one-of-a-kind miniature golf course. The course must have a theme and you need to present design sketches to your investors.

When snorkeling you came across this grand coral reef and the exotic underwater creatures that inhabit the reef. Recapture it.

ou're riding on a first class airline flight that combines a limo with a jetliner.
ketch the interior and all the amenities.

ketch your favorite place to just think. Sketch what inspires you there.

A mouse outsmarting a trap, it can get cheesy.

A grand piano topped with a candelabra—make the candles melt.

ou are a shapeshifter for a day. Sketch yourself shifting.

A rugged man with a very cool beard.

A fire escape (at least 3 stories) on the side of an old warehouse building.

Medusa is staring at you, make her serpents stand out.

A fairy sitting on a mushroom.

sultry eyes with long lashes and character.

A ballerina in a pose.

A high school science class scene.

A lucky charm.

A deluxe pinball machine.

Sketch a scene from your favorite movie.

Give a skateboard a facelift, make it jet propelled and make the wheels transform.

You're being chased by a herd of creatures, but you're too afraid to turn around. You take a selfie over your shoulder. Sketch what your camera sees.

An Egyptian pharaoh complete with headdress.

A scene from the ocean floor.

A cyclops just walked through your front door.

You're inside a grand opera house—sketch what you see.

bonsai tree.

A thriving metropolis.

Sketch something inspired by Roy Lichtenstein.

scene inside your favorite video game.

eflections of the clouds and sky in someone's sunglasses.

A snow skier on a dangerous slope.

Sailboats in a harbor

technology company is working on personal space pods people can purchase to travel to Mars without using a space shuttle. They have hired you to sketch these new space pods.

A black widow and her web.

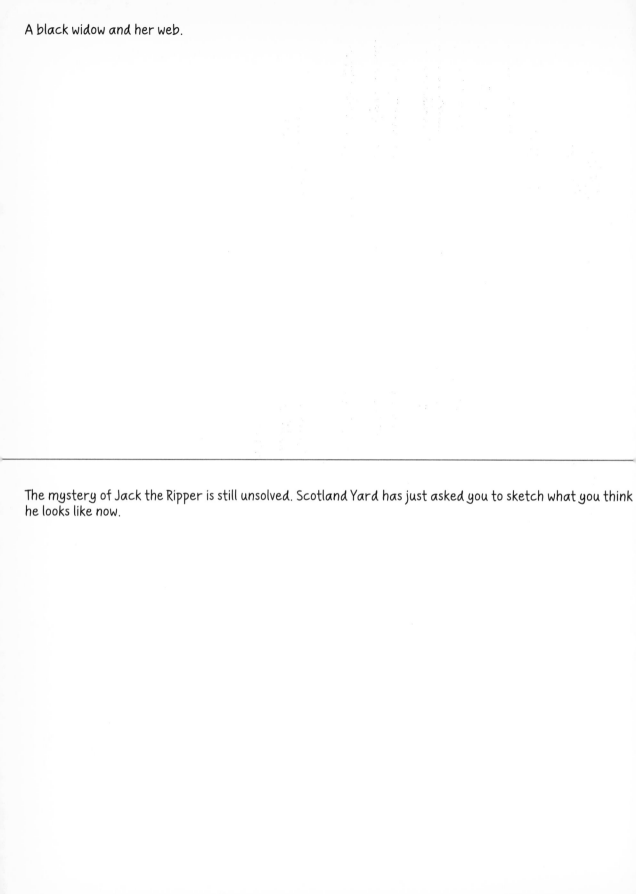

The mystery of Jack the Ripper is still unsolved. Scotland Yard has just asked you to sketch what you think he looks like now.

A Wild West saloon.

Something has been making noise in your attic all week. Reluctantly you go up there to see what it is. Sketch your findings.

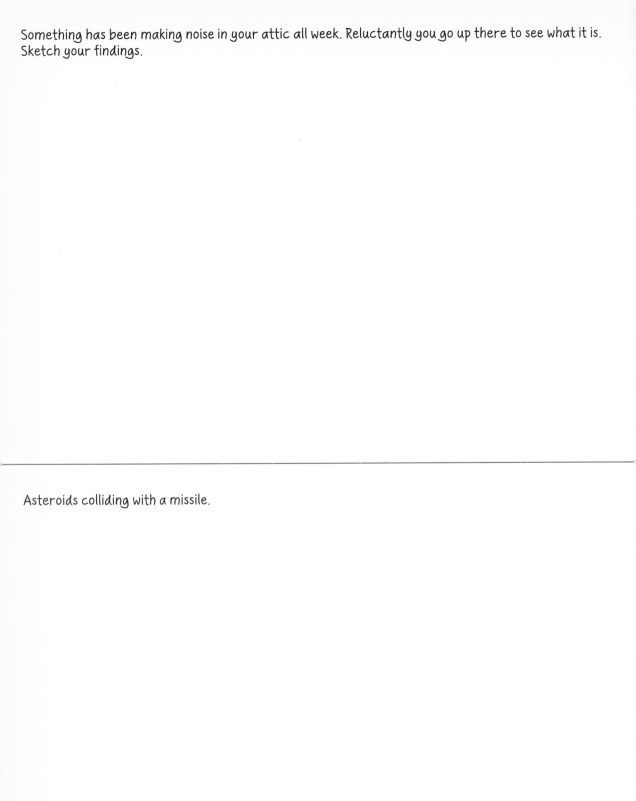

Asteroids colliding with a missile.

An Elvis impersonator.

You're giving a medal to your hero. Sketch the medal, especially what is on the face of it.

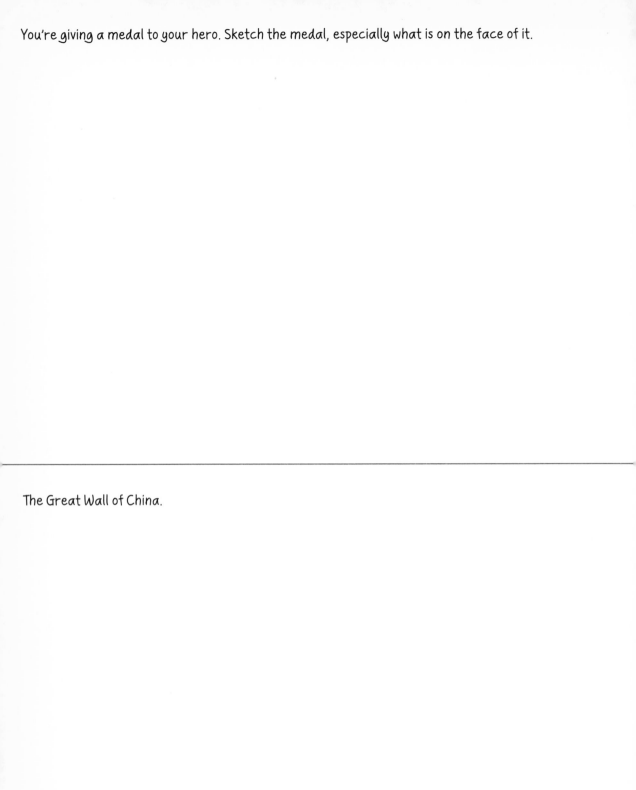

The Great Wall of China.

A peacock with tail feathers fanned open.

A mermaid head to tail sitting on a rock.

Wizard of Oz had the Lollipop Kids, Willy Wonka had Oompa Loompas, now you're hired to sketch tiny characters for a new movie.

If you had an alter ego, what would it look like?

A vintage broach.

A radioactive fly.

A lighthouse, lighting the way.

A carved Jack-o-lantern face.

Give something outdated a new purpose—sketch the repurposing.

Two penguins kissing.

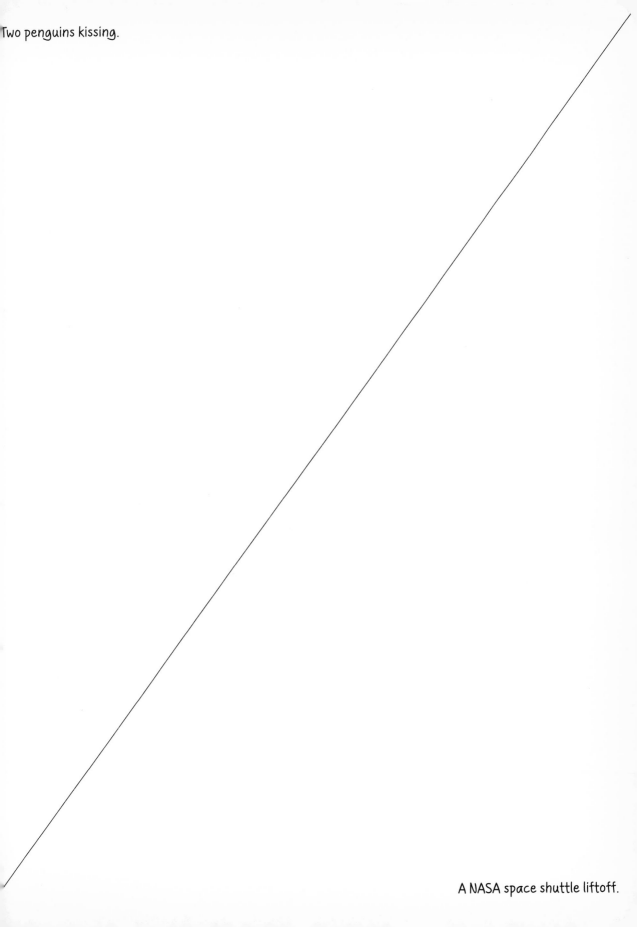

A NASA space shuttle liftoff.

A crocodile smile.

A genie leaving his bottle.

You've just taken the most awesome photo ever. Sketch the photo.

What do you think cavemen looked like?

Sketch your hometown in 3-D map style, and highlight the attractions and architecture.

An old church with a steeple and bell.

An earthquake has shifted the Grand Canyon. Sketch the aftermath.

The Queen of England needs a new throne, sketch the design plans and make it fit for a queen.

The President of the United States has asked you to sketch plans for a new White House.

A new solar power invention.

An underground fortress.

Someone accidentally bred a dog and cat together. Sketch the crossbreed.

A scuba diver descending into the abyss.

You just sat down with a shaman, sketch all his details.

Moonlight casting a shadow on something.

A traveling circus called "The Weirdest Show on Earth" has just arrived at your city. Sketch the weirdest attraction they have.

A dollhouse you'd want to give your daughter.

Your perception of a ghost taking shape.

A pirate ship—complete with sails, cannon and crow's nest.

A revolutionary space station.

A museum exhibit you love.

Your favorite hobby.

Think of the hardest thing for you to try and sketch. Now attempt it.

What do you think the Hanging Gardens of Babylon looked like?

A plasma ball meets a hand.

A city in the clouds.

Sketch what you feel is the biggest apex predator on Earth.

A robin's nest with eggs.

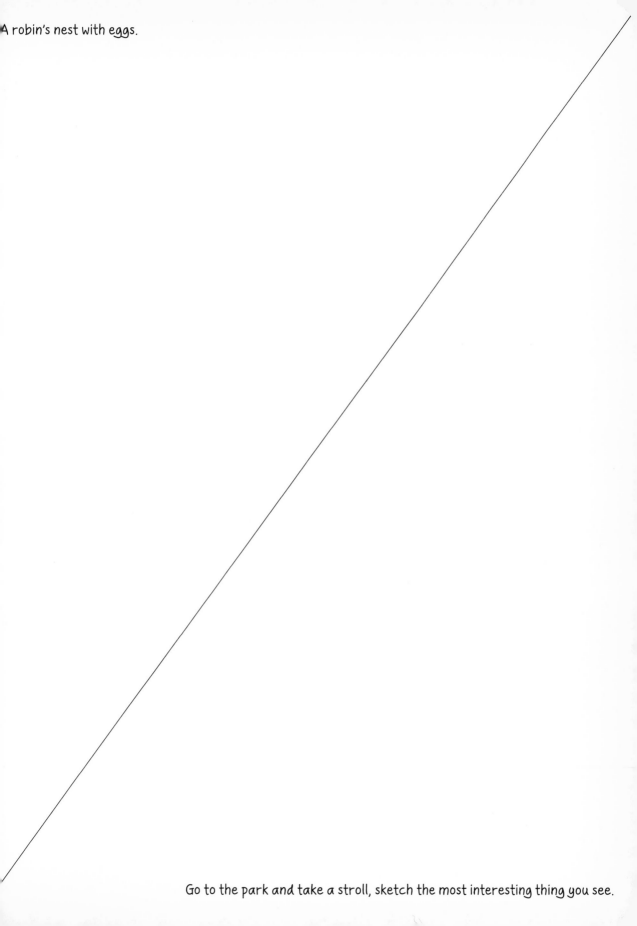

Go to the park and take a stroll, sketch the most interesting thing you see.

Pick the title of any movie, and then sketch the title.

A used pair of sneakers.

People paddling down rapids while river rafting.

An acoustic guitar you want to play.

An eerie porcelain doll.

Sketch the lyrics to your favorite song.

You're at a carnival and just won a prize, sketch the game you won it on.

If you could be a superhero, what would you want your costume to look like?

What do you think the Phantom of the Opera really looks like?

Somebody just called in the cavalry, what does it look like?

A UFO landing in the city.

Sketch looking on the bright side.

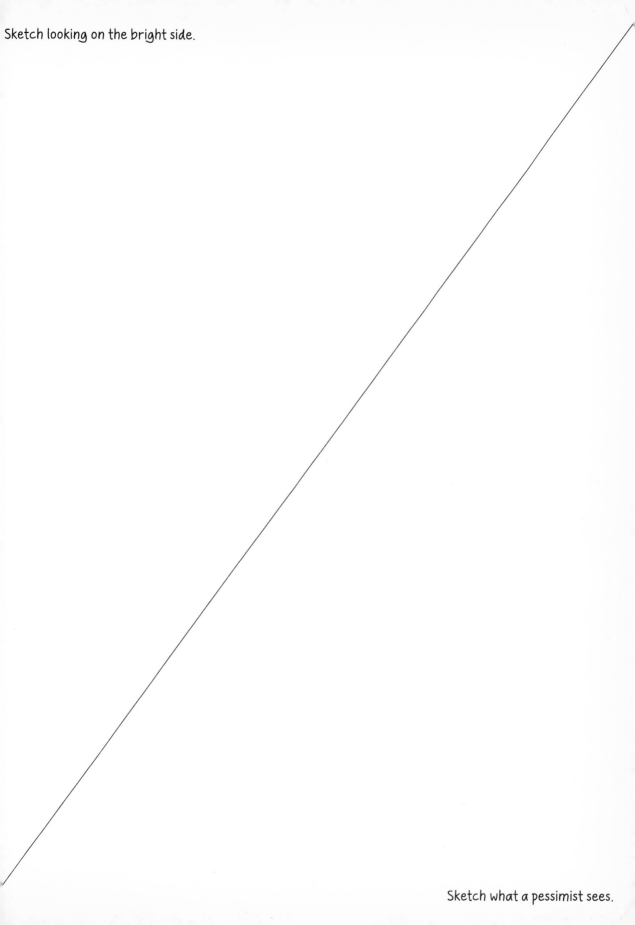

Sketch what a pessimist sees.

Your ultimate Halloween costume.

New football uniforms for the NFL.

Walking on a military base you see the newest model stealth aircraft.

You're parasailing and you spot a shark coming at you, sketch it.

Sketch a superstition.

Inside an abandoned asylum or sanitarium.

If Albert Einstein and the Easter Bunny had a baby, what would it look like?

You've got a feeling of déjà vu, sketch what gave you this feeling.

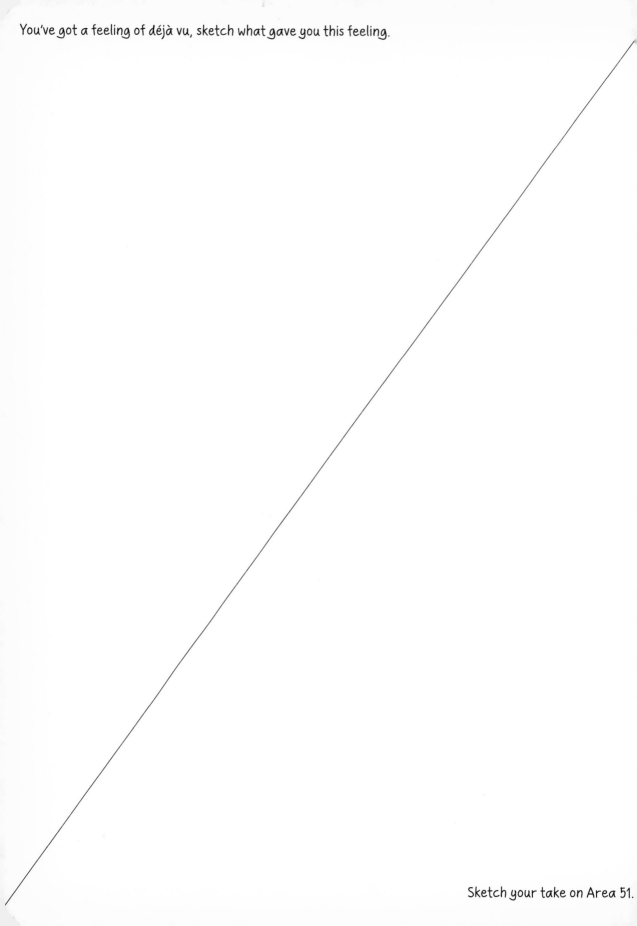

Sketch your take on Area 51.

A futuristic car that can fly.

You've just met your fairy godmother.

A vault so intricate it's burglar proof.

A happy Buddha.

What you think a totem
pole looks like.

A mummy's tomb.

Give the Mad Hatter a new identity.

Something from the Renaissance time.

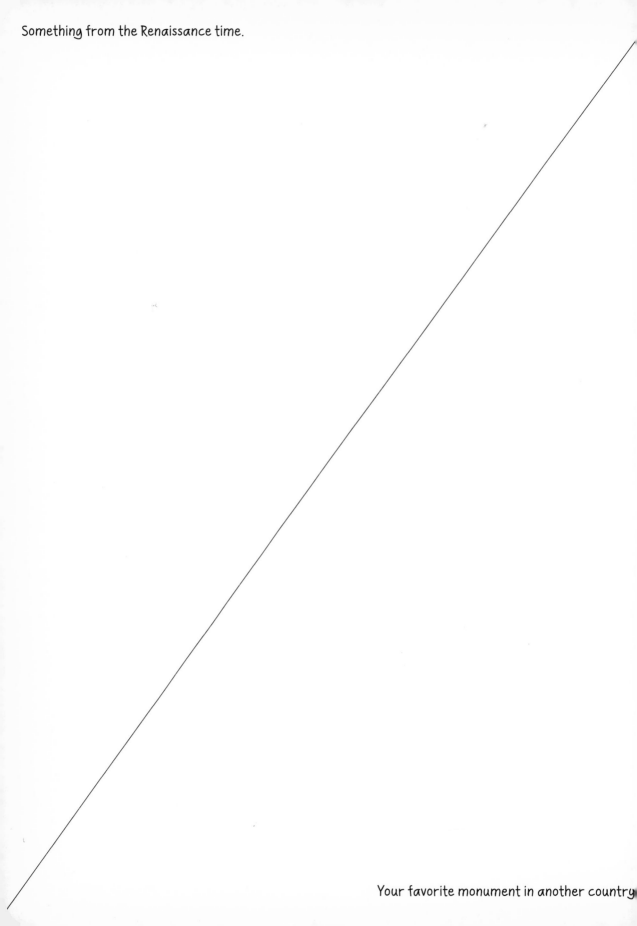

Your favorite monument in another country

walrus versus an orca.

Turn a politician into a funny caricature sketch.

A magical form of transportation.

The Headless Horseman riding again.

What you think heaven looks like.

Your mind is playing tricks on you...sketch it.

Sketch a scene with no gravity.

You're trying to set a world record for climbing the highest, sketch what you're climbing.

In 1978 a spoof movie called "Attack of the Killer Tomatoes" became a hit but no sequel was ever made until now…replace the tomatoes and sketch the attack.

Sketch the evolution of man according to your theory.

Sketch your favorite fable.

The most beautiful thing you can think of.

Sketch your favorite board game, and make it come to life.

Reinvent the wheel.

Something that scared you as a child.

An urban legend.

Rats have taken over the world.

You're inside a submarine, what does the command center look like?

A computer virus trying to escape a laptop.

Design and sketch a new symbol of peace for the world.

You're in charge of a new sculpture for the Smithsonian. Sketch it.

Sketch your own urban mural on a brick wall.

If you had a dog, create the most ultimate doghouse.

You're talking to a group of kids about a new cartoon Martian, sketch it for them.

You've discovered Bigfoot. Sketch what he looks like to you.

You're on an archeologist expedition. Sketch something you found.

An elevator that can transform into a time machine.

A devil on your shoulder.

A creature emerges from the fog...what do you see?

An international spy needs new gadgets, sketch the design plans for them.

A piñata whacked open, what is spilling out?

You're in charge of sketching a new trophy for a major award show.

Your dream backyard swimming pool.

Something you'd use to communicate with spirits.

An epic tree house.

If you were to get a tattoo, sketch what you'd give the artist to put on you.